DOUBLE EXPOSURE

# PICTURING CHILDREN

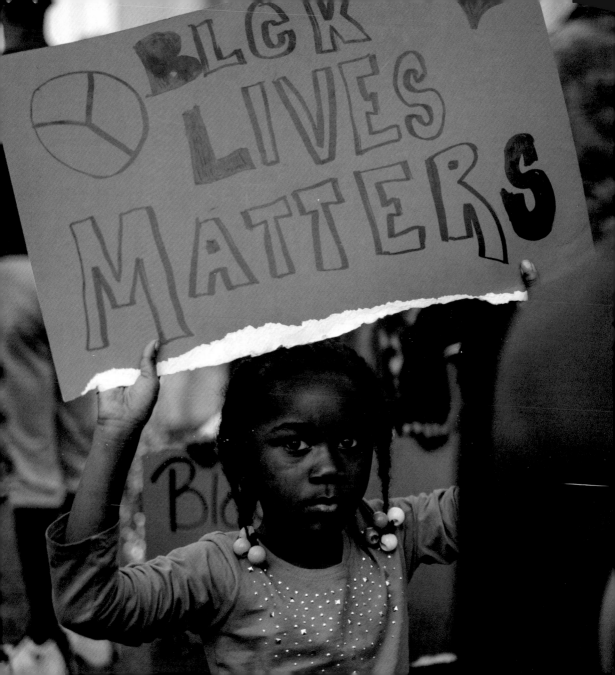

DOUBLE EXPOSURE

# PICTURING CHILDREN

Photographs from the National Museum of
African American History and Culture

NATIONAL MUSEUM
OF AFRICAN AMERICAN
HISTORY & CULTURE

Earl W. and Amanda Stafford
Center for African American Media Arts

GILES

National Museum of African American History and Culture
Smithsonian Institution, Washington, D.C., in association with D Giles Limited, London

**For the National Museum of African American History and Culture**
Series Editors: Laura Coyle and Michèle Gates Moresi
Editorial Assistant: Douglas Remley

Curator and Head of the Earl W. and Amanda Stafford Center for African American Media Arts: Rhea L. Combs

Publication Committee: Aaron Bryant, Rhea L. Combs, Laura Coyle, Michèle Gates Moresi, Douglas Remley, and Jacquelyn Days Serwer

**For D Giles Limited**
Copyedited and proofread by Jodi Simpson
Designed by Alfonso Iacurci
Produced by GILES, an imprint of D Giles Limited, London
Bound and printed in China

First published in 2016 by GILES
An imprint of D Giles Limited
4 Crescent Stables
139 Upper Richmond Road
London
SW15 2TN

ISBN: 978-1-907804-75-5

All measurements are in inches and centimeters; height precedes width precedes depth.

Photograph titles: Where a photographer has designated a title for his/her photograph, this title is shown in italics. All other titles are descriptive, and are not italicized.

Front cover: A young girl and boy posing with a picture frame, mid-20th century (detail), Gaston L. DeVigne II
Back cover: James Baldwin and Paula Baldwin, 1953, Unidentified photographer
Frontispiece: A young girl at a Baltimore City Hall rally, May 3, 2015 (detail), Devin Allen
Page 6: Valdora Turner as a young girl, ca. 1922 (detail), Unidentified photographer

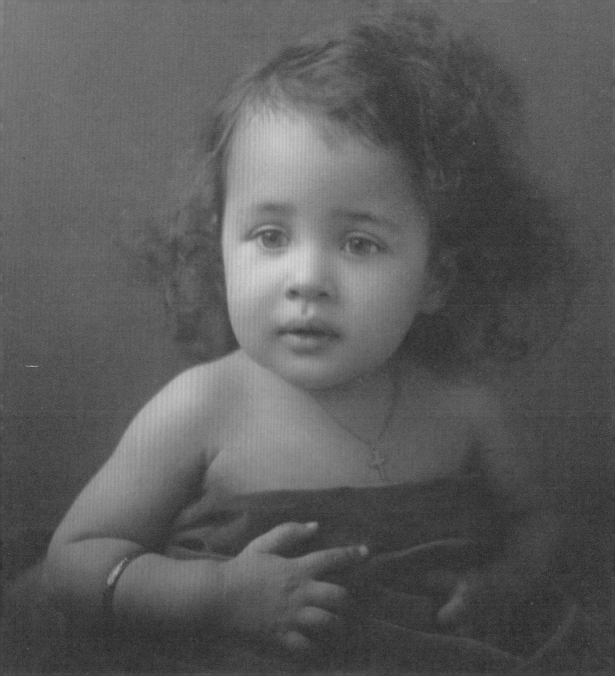

# Foreword

It is fitting that our next volume in the *Double Exposure* series focuses on images of children. We are echoing the efforts of W. E. B. Du Bois, who presented to readers of *The Crisis* visual reminders of what and for whom we toil: our youth. *The Crisis: A Record of the Darker Races* was the official publication of the National Association for the Advancement of Colored People (NAACP), edited by Du Bois from 1910 to 1934. The very first issue featured a sketch of a little girl on the cover. Beginning in 1912, every October Du Bois published a "Children's Number" with images of children, editorials, and articles. We are fortunate to have in the National Museum of African American History and Culture (NMAAHC) collection both a copy of the 1922 "Children's Number" and the photograph of the very young girl, Valdora Turner, that graced its cover.

As a magazine dedicated to current affairs surrounding racial issues, an extension of an organization strategizing to achieve social justice and racial equality, why feature images of children? The goal of *The Crisis* was broader than reports on the infringements on African Americans' civil rights. By publishing literary works, such as poems, short stories, and essays, Du Bois sought to engage readers of varied backgrounds so that they were not only informed, but also educated about the relentless work of "social uplift."

Images of black people as only poor destitute sharecroppers, locked into the lowest tier of society, were pervasive in the American psyche and also threatened to overwhelm African American self-perceptions. DuBois countered this with images of accomplished and educated African Americans, and pictures of their children. While some blacks experienced social and economic mobility, unfortunately many other black youth and their families continued to experience poverty; photographs in this book depict both realities and multiple experiences. He strongly encouraged his audience to be aware of the talents and achievements of "the darker races," and the annual "Children's Number" engaged fundamental issues of social betterment to foster more opportunity and achievement in the future. While African American readers in 1922 did not have full equality, their collective goal was to make sure Valdora would have it—and, even more important, to make sure Valdora was ready to take advantage of it.

*Picturing Children* harkens back to the "Children's Number" issues of *The Crisis* because we still need these reminders. To say that "children are our future" sounds trite, but it is nevertheless true. Du Bois's commentaries stressed the need for progress, knowing full well that race relations could only improve

if future generations were prepared to make it happen. With gravitas, Du Bois wrote, "We know that children are the only real Progress, the sole Hope, the sure Victory over Evil. Properly reared and trained and there is no Problem or Wrong that we cannot withstand."¹ America has progressed and race relations have changed, but we also know that racism persists and our work is not complete. In this collection of over 50 images of children, we catch glimpses of African American life, past and present, which prompt us to consider our responsibilities to youth, not only as a moral obligation, but as an essential venture in shaping our future.

NMAAHC is dedicated to documenting diverse experiences that allow us to view American stories through an African American lens. *Picturing Children* is the fourth book in a series of publications, *Double Exposure*, featuring unique photographs from the Museum's collection. It draws on the Museum's growing photography collection of over 20,000 images that also supports our innovative Earl W. and Amanda Stafford Center for African American Media Arts (CAAMA). CAAMA, as a physical and virtual resource within NMAAHC, exemplifies the Museum's dedication to preserving the legacies of African American history and culture. The photographs in this volume present images of youth who are in a sense history makers, active and engaged, making a way for themselves and, by extension, for the rest of us.

Activists and advocates of youth, acutely aware of history, continue to agitate for justice and real change. I am so proud to have Marian Wright Edelman, the founder and president of the Children's Defense Fund (CDF), contribute her thoughts on the photographs in this book. Innovative CDF projects, such as the Cradle to Prison Pipeline® campaign, provide significant resources and practical programs to improve conditions for disadvantaged youth. Her words inspire all of us to look at

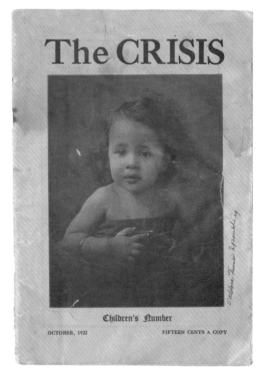

these images thoughtfully and consider "a quiet call to action." I would like to thank Dr. Ivory Toldson, executive director of the White House Initiative on Historically Black Colleges and Universities and founding director of the Center for Research, Evaluation, Assessment, and Training in Education (CREATE, LLC), for his insightful essay about the role of chance and caring in the life of a child. Dr. Toldson has dedicated his career to improving education and opportunities for African American students. From our Museum, Anna Forgerson Hindley, Early Childhood Education Coordinator, contributes her knowledge of childhood development in the opening texts of each section, and Margaret Turner, Senior Major Gifts Officer, writes of her experiences in 1968 as a volunteer in a preschool daycare tent at Resurrection City.

I am equally pleased to have two contributors, Patrisse Cullors and Mark-Anthony Johnson, artists and organizers of #BlackLivesMatter and Dignity and Power Now, to express heartfelt and meaningful ideas reflecting the urgency of their tremendous work in social justice. In addition,

world-renowned photographer Jamel Shabazz generously shares the moment of taking the photograph *Flying High* (see p. 54), revealing his own childhood experience that so profoundly shaped his development as a photographer.

Many other people collaborated on this important book and landmark series. At the Museum, special acknowledgement is due to the publications team: Jacquelyn Days Serwer, Chief Curator; Michèle Gates Moresi, Supervisory Museum Curator of Collections, who acted as team leader on this project; Rhea Combs, Curator of Photography and Film, and Head of the Earl W. and Amanda Stafford Center for African American Media Arts; Laura Coyle, Head of Cataloging and Digitization, whose work made the reproduction of these photographs possible; Aaron Bryant, Andrew Mellon Curator of Photography; and Doug Remley, Editorial Assistant. Elaine Nichols, Senior Curator for Culture, and Esther J. Washington, Director of Education, provided invaluable input throughout the course of this project, while support and encouragement from our Associate Director for Curatorial Affairs, Rex Ellis, has been invaluable to the continuation of the series.

We are also very fortunate to have the pleasure of co-publishing with D Giles Limited, based in London. At Giles, I particularly want to thank Dan Giles, Managing Director; Alfonso Iacurci, Designer; Allison McCormick, Editorial Manager; Sarah McLaughlin, Production

*The Crisis*, vol. 24, no. 6,
October 1922
National Association for the
Advancement of Colored People

Director; and Jodi Simpson, copyeditor. Finally, I would like to thank our entire Digitization Team for researching, cataloging, digitizing, and preparing all of the images and captions included in this volume.

I am so pleased to continue this series with images of children and to share this special selection with our public. We remain steadfast in our commitment to document African American history, and, like me, I trust you will be inspired by the photography collections at the Smithsonian and beyond.

**Lonnie G. Bunch III**
*Founding Director*
National Museum of African American History and Culture, Smithsonian Institution

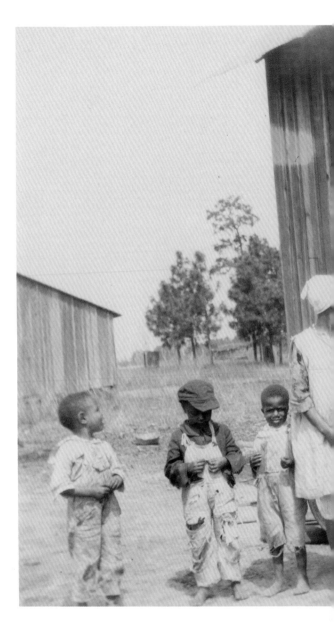

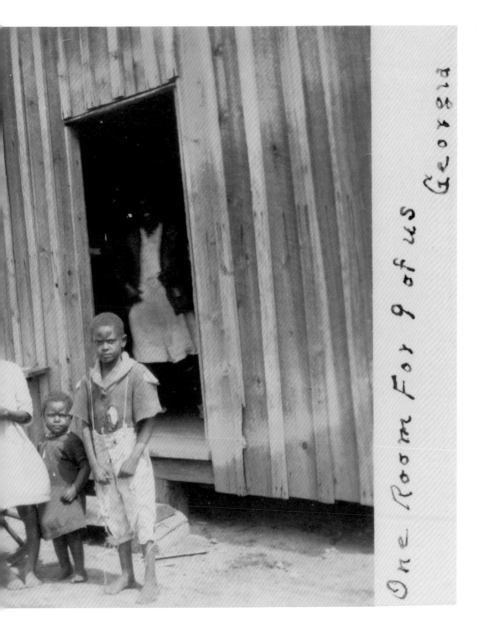

One Room For 9 of us Georgia

Family in front of
Georgia home, 1930s
Unidentified
photographer

# Our Turn

**Marian Wright Edelman**
*Founder and President of the Children's Defense Fund*

am very grateful for this beautiful new book and the extraordinary range of images of African American childhood it captures, showing us many commonalities that run across color and time.

The pride and love black families have always felt for their children are strong themes running through *Picturing Children*. African American adults have long done their very best to protect their children from a society that does not always value them highly and to remind them that, no matter what the outside world says, they have dignity and sacred worth that no outside force can touch. Our mothers and grandmothers took their time braiding our hair, neatly pressing our clothes, and reminding us every day that "Black is beautiful" long before the phrase became popular. We see the legacy of generations of family and community care in many of these pictures.

The family portraits begin right before Emancipation and represent bonds that not even slavery could undo. Some include famous adults, such as proud father Jackie Robinson (see p. 21), beaming big brother James Baldwin (see p. 33), and pioneering football player

Marion Motley with his young sons around a train set (see p. 29), in scenes that could have been plucked from any family album. Children are dressed for musical performances, in sports uniforms and dance costumes, and in their Sunday best, all showing the many ways adults took time to nurture their children's individual gifts and beauty. There also are more candid moments—children studying, worshiping, playing—glimpses of beauty all their own. I see a picture of a children's choir from my own church, Shiloh Baptist in Washington, D.C. (opposite), and instantly hear their sweet voices rising in praise.

Another set of photos reminds us that African American children have often been encouraged and supported as change agents who can make a difference; they have marched and been attacked right alongside, and sometimes without, adults. We see a boy on a white minister's shoulders at the Selma to Montgomery March (see p. 75); a girl gazing from a tent at the Poor People's Campaign's Resurrection City (see p. 76); some of the brave teenagers who were part of the Little Rock Nine (see p. 83). In contrast is a moment of quiet brotherhood from the 1940s: two nearly

*The Children's Choir of Shiloh Baptist Church, Washington, D.C., 1998*; printed 2012
Jason Miccolo Johnson

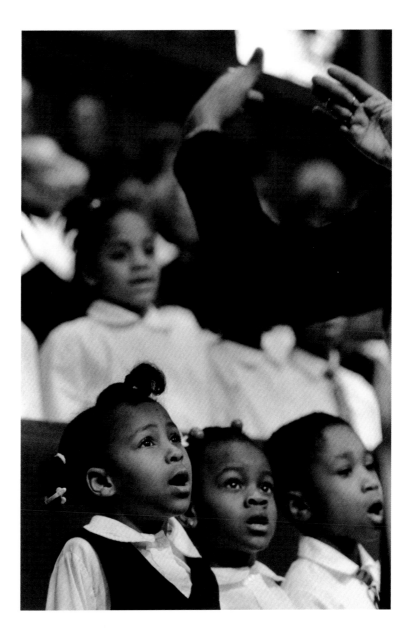

identically dressed young boys sit companionably side by side, one black, one white (see p. 64). How differently did their lives turn out?

Among the many images of children buoyed and protected by family love and support, we also see children on their own, some creating joy out of the best resources they have available: an abandoned mattress turned trampoline (see p. 54), an opened fire hydrant on a summer day (see p. 48). And then there are those photographs where a child seems very alone. A boy sits on a church pew (see p. 65); a small girl looks pensively out a window (see p. 57). What are those children thinking?

All of these pictures should serve as a quiet call to action, and a reminder of how much all African American children desperately need all of us to reweave the fabric of family and community that sustained them for so long. The distinguished theologian Dr. Howard Thurman once described an oak tree in his childhood yard with leaves that each autumn turned yellow and died but stayed on the branches all winter. Nothing—neither wind, storm, sleet, nor snow—dislodged these dead leaves from the apparently lifeless branches. Dr. Thurman came to understand that the business of the oak tree during the long winter was to hold on to the dead leaves before turning them loose in spring so that new buds—the growing edge—could begin to unfold.

At winter's end, what wind, storm, sleet, and snow could not force off passed quietly away to become the tree's nourishment.

Throughout most of our history, black families have been like that oak tree. Despite enormous assaults and pressures, parents and elders remained determined to hold on and persevere long enough to prepare the next generation and give them a better life. This is the story reflected throughout *Picturing Children.* A photograph of the nation's first African American president bending to let a young boy feel his hair (opposite) is a powerful reminder of how far we have come.

But we still have so far to go. African American children face many threats and assaults on their wellbeing today. A toxic cocktail—poverty, resegregation, unequal schools, massive illiteracy and innumeracy, racial disparity in every child-serving system, violence, and a pipeline to prison that feeds a mass incarceration system—is sentencing millions of children of color to dead-end, powerless, and hopeless lives. These injustices threaten to undermine the past half-century of racial and social progress. Those of us who see the threads of our families, neighborhoods, and social networks fraying and breaking under this burden must wake up and act. Our children were nurtured and protected in the past through the unstinting hard work of

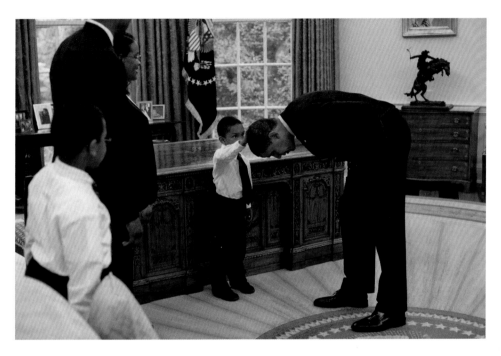

committed and determined adults. Today, it's
our turn. We must not let them down. It's time
for a powerful new transforming movement to
protect, celebrate, educate, love, and prepare
all of our children for the future. If we let our
children move backwards, so goes our African
American community, so goes our nation, so
goes our future.

*Jacob Philadelphia Checks
Out President Obama's
Hair in May 2009*
Pete Souza

# Picture This

**Ivory A. Toldson**
*Executive Director of The White House Initiative on HBCUs*

Imagine this: a city planner looks at a photograph of a child doing a backflip on a discarded mattress, like Jamel Shabazz's *Flying High* (opposite), and is immediately inspired to create a policy to develop a park in an underserved community. A child growing up near this new park loves exploring various types of plants. As she grows from childhood into adolescence, her fascination with plant life evolves from imaginative to scientific. Eventually, she learns about the process of extracting chemicals from flowers for medicinal purposes and decides to major in biology at college. Throughout school, her knowledge of life and health expands, and she ultimately achieves a Ph.D. in molecular biology. Later, she develops a lab at a medical school and discovers a cure for cancer. The world changes, not only because of one young woman's discovery, but also because a picture inspired someone. Big things happen because of small events.

*Picturing Children* invites viewers to see the potential for the extraordinary in the ordinary affairs of children. In order to do this, first we must understand that our ability to transform lives is affected by randomness, improbability, and chaos. Second, we must resist the impulse to prognosticate based on superficial observations. Finally, we must remove artificial barriers that hold children back, and expand our notions of possibilities for African American children.

For more than a century, scientists have tried and failed to create a range of metrics designed to predict behaviors and outcomes for children. Widespread and unqualified use of IQ and achievement testing, as well as such social barometers as zip codes, poverty levels, and household compositions, have resulted in children being labeled "at risk," tracked, and stuck in a rut of low expectations.

Recently, in a meeting with high-level stakeholders, I heard a policymaker admonish the public school system because more than half of the children he represented were "behind" by the first grade, based on the district's interpretation of a test that they administer to kindergarteners. "If kindergarteners in your generation or mine were given the same test, do you think we would have done much better?"

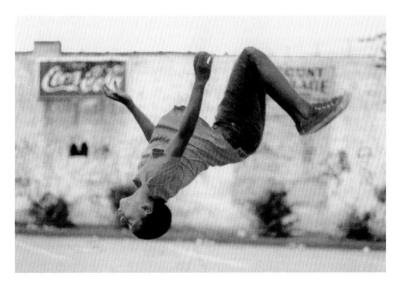

*Flying High*, 1981;
printed 2010 (detail)
From the series Back
in the Days
Jamel Shabazz

I asked. He was miffed by the question, but allowed me to elaborate.

As a psychologist and educator by training, I explained the nature of cognitive development in early childhood. I described the inherent danger in using such measures to predict first grade readiness without considering the child's social and emotional adjustment to school. Overall, the dialogue was constructive, but I remain disturbed by the number of people willing to write off children who don't hit certain arbitrary benchmarks by a certain time.

When it comes to educating children, it is never too early, and it is never too late.

Today, society is very attuned to the "early" part of education, because of our impulse to mold, predict, and control. We often stress the importance of early learning experiences by examining the failures of older students. We say things like, "If a child hasn't mastered 'this' by 'then' he/she will never be able to catch up."

At the same time, we ignore the nonlinear developmental processes. Many people, after spending many years of their

childhood "behind," succeed because of chance meetings with people who do nothing more than care. Someone believed in these children and helped them believe in themselves. Children who overcome seemingly insurmountable odds often refer to a "click"—a simple thing that triggered a new outlook and inspired them to press on despite obstacles and relentless attempts by adults to underestimate them. Exceptional children, like the children in this book we see singing, marching, reading, and playing, are not the exception, but the norm.

Understanding the delicate balance between insight and scientific observations is key to educating in a diverse context. Great educators are not dependent upon metrics, which are often designed for social control, but are visionaries who can see something extraordinary in the ordinary—just as James Karales (see p. 75) and Roderick Terry (see p. 79), in their photographs of boys sitting on the shoulders of men, recognize the remarkable experience of a child seeing the world through the elevated perspective of an adult. Great educators do not rely on superficial observations; they incorporate creativity, the sciences, and psychosocial development into their practice to expand children's possibilities.

As an educational leader, I believe that many inferences that adults make about children, based on tests and other measures, are hindering the intellectual and personal development of millions of children. *Picturing Children* reflects on the promise and potential of our future without the limitations of scores and statistics. Children thrive among adults who are experts in reading facial expressions and body language, not diagrams and charts. The photographs in this book allow us to appreciate the chaos in our world and the beautiful improbability of being. At the same time, they present children as inspirational and foster a sense of hope for us all. If you are fortunate enough to experience this volume of compelling images, understand the power that you have to inspire the children within your own sphere of influence to be great.

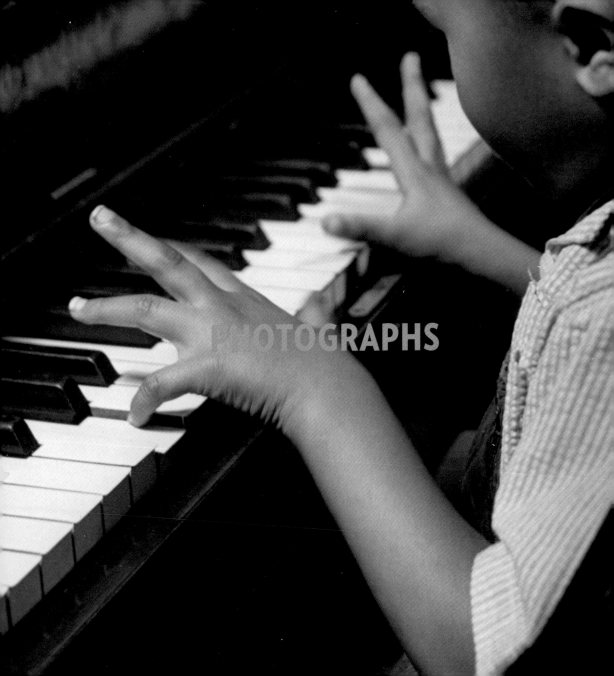

# FAMILY

Often among our most prized possessions, family photographs help us understand our personal histories. They spark memories, providing a tangible link to the past. Images of family also greatly influence common understandings and expectations for the roles we all play, particularly for children.

Family, no matter how it is defined, is primary in shaping who we are. A basic unit in almost every society, family is important to the developmental, emotional, and cognitive growth of a child, for a young person's understanding of the world begins at home. Healthy families of all kinds are characterized by commitment, nurturing support, effective communication, a safe environment, and the exchange of culture and values. Family photos are one way to represent these characteristics visually and help children to establish a sense of self.

Many African American families prepare their children early in life for a diverse world and potential discrimination.[2] Involuntary immigration and enslavement led to hundreds of years of social and economic oppression, which persists today. While there is no monolithic story, African American families often find stability in cultural identity and extended communities that provide resources, both emotional and practical, to protect and strengthen the family unit.

This section features portraits and snapshots over time of African American families, both well known and anonymous. Each image tells multiple stories. Often they remind us of the importance of an engaged and committed family. Photographs of iconic figures in familial settings can also shed a different light on history. Whether it is Jackie Robinson with his wife and son smiling warmly or Dr. Martin Luther King Jr. embracing his son in a candid moment, we see another, more intimate, view of these extraordinary individuals. Family photos are simultaneously personal and universal. You may even see glimmers of recognition of your own family in the following pages: how you felt as a child when you enjoyed the love in your mother's gaze, idolized your brother, laughed with your sister, or were lifted high into the air by your father.

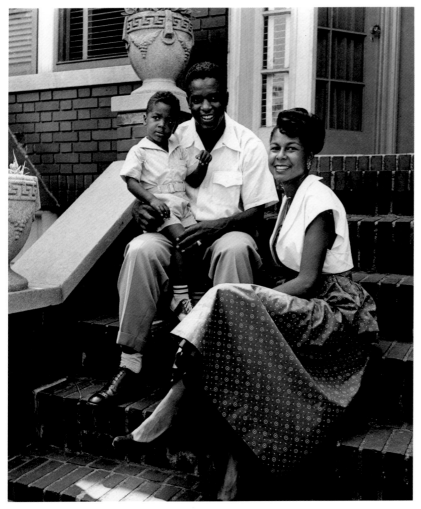

**Jackie Robinson with His Wife and Son**, 1949; printed 2005
Nina Leen

—

Jackie, Rachel, and Jackie Robinson Jr. sitting on the front steps of their home in Brooklyn.

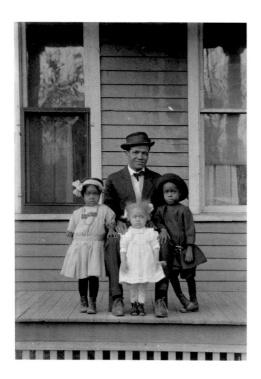

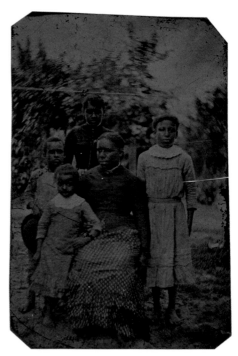

**Manitoba James and
his children Myrtha,
Edna, and Mauranee,**
1919–25; scanned 2012
John Johnson

**A woman and four
children**, 1870s
Unidentified
photographer

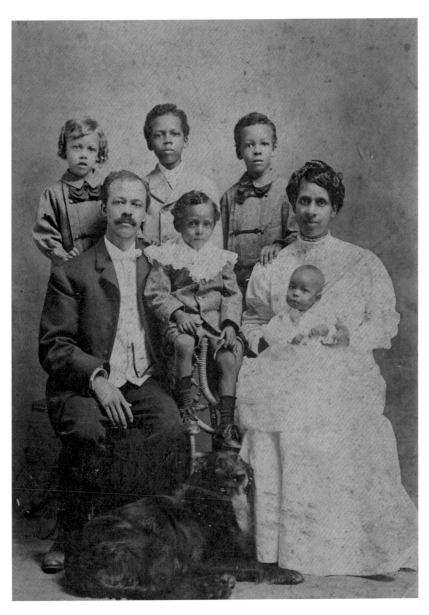

**Senator Henry Hall Falkener and family**, ca. 1905
Unidentified photographer

—

Family photographs have long served as symbols of aspiration, agency, and memory for children and adults alike. In this image, though, one also sees legacy. Margaret Falkener and her husband, North Carolina State Senator Henry Falkener, pose with their five sons, Ralph, Hershel, Harold, Waldo, and Quentin. Education, politics, and activism were central to the family's life and history. Following the family's tradition as political activists, Waldo was elected to the Greensboro City Council in 1959, and he participated in the Greensboro lunch counter sit-ins in 1960. For the Falkeners, political participation was a family affair.

23

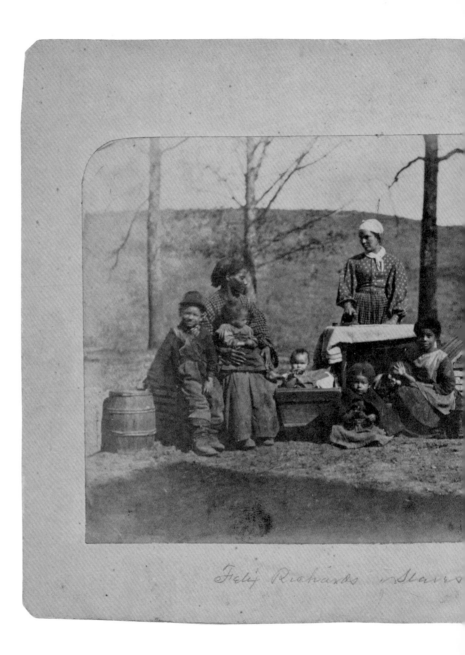

Felix Richards, Slaves

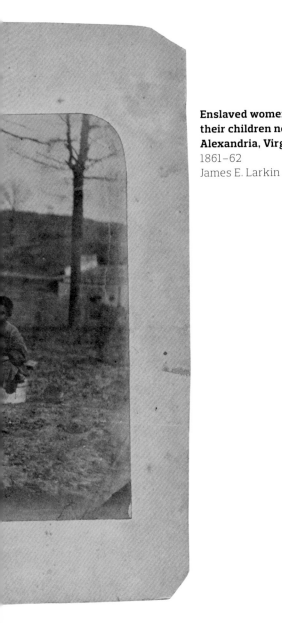

**Enslaved women and their children near Alexandria, Virginia**, 1861–62
James E. Larkin

Pictured here are Lucinda Hughes with her children William and Fannie, and her sister-in-law Frances Scott Hughes with her children Mary, Martha, Julia, Harriet, and either Charles or Marshall. When photographed, the women and their children were enslaved at Felix Richard's Volusia Plantation. This albumen print was taken by James E. Larkin, a hobby photographer and an officer in the 5th New Hampshire Volunteer Infantry during the Civil War. He took the photograph while stationed near Alexandria, Virginia, between December 2, 1861, and March 10, 1862. The women and children were freed on January 1, 1863, by the Emancipation Proclamation.

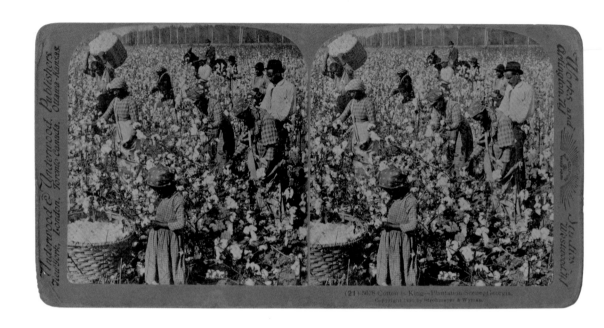

***Cotton is King –***
***Plantation Scene,***
***Georgia,*** 1895
Strohmeyer & Wyman

*Georgia · **USA,*** 1964
Leonard Freed

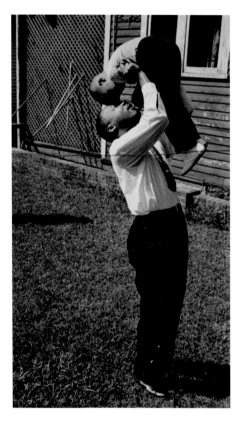

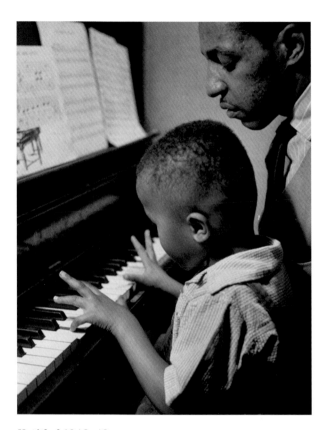

**Dr. Martin Luther
King, Jr., and Martin
Luther King III**, 1962
James H. Karales

**Untitled**, 1946–48
**Piano lessons**
From the series **The Way of
Life of the Northern Negro**
Wayne F. Miller

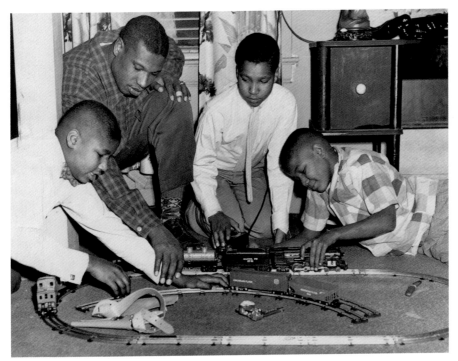

**Marion Motley
with sons**,
December 1953
Fred Bottomer
—
In 1946, Marion Motley
signed as a fullback
for the Cleveland
Browns, becoming one
of the first African
Americans to play
professional football.
This photo depicts
Motley and his
three sons, Ronald,
Raymond, and Philip,
playing around a toy
train set.

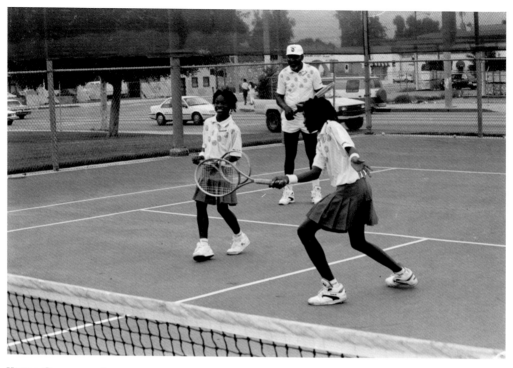

**Venus, Serena, and
Richard Williams**, 1991
Roderick J. Lyons

*"Family's first, and that's what matters
most. We realize that our love goes
deeper than the tennis game."*

Serena Williams

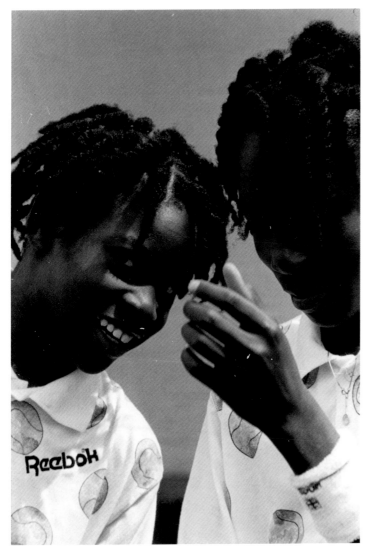

**Venus and Serena Williams**, 1991
Roderick J. Lyons

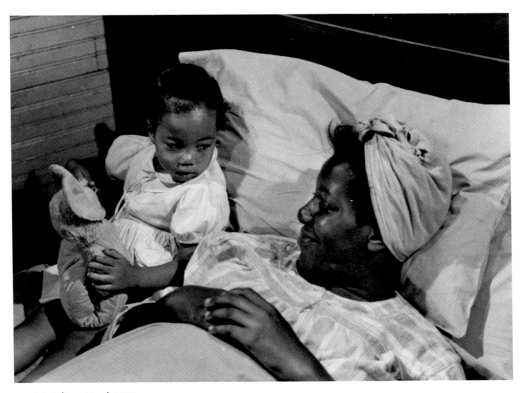

***Untitled (Bonding)***, 1952
From the series
**Reclaiming Midwives:**
**Stills from *All My Babies***
Robert Galbraith

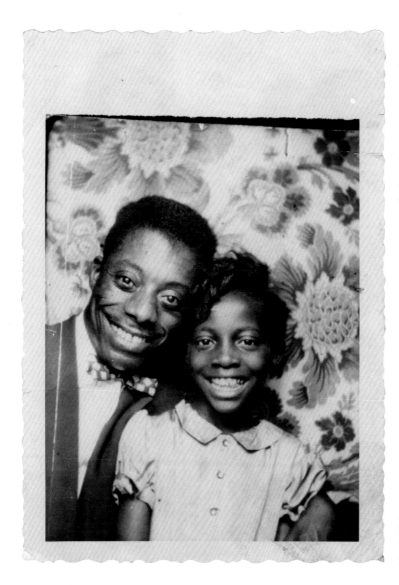

*"The world is before you and you need not take it or leave it as it was when you came in."*

James Baldwin, *Nobody Knows My Name*, 1961

**James Baldwin and Paula Baldwin**, 1953
Unidentified photographer

33

# COMMUNITY

We all have heard the saying "It takes a village to raise a child," but what is a village, really? In modern times, the village takes the form of a community, and plays a major role in rearing and nurturing children. A supportive relationship between families in any community—neighborhoods, cities, school groups, or faith organizations—is a basic ingredient for emotional strength. Communities support the development of children physically, intellectually, emotionally, and socially when they are actively serving and engaging individual families. Such meaningful involvement provides a baseline for positive experiences from which a child can learn, grow, and thrive. When people take responsibility for the young in their community, they aim to ensure that the adults of tomorrow will be well adjusted and equally invested in the wellbeing of others.

   Vibrant networks of people give children many ways to contribute and develop life-long skills. Beyond their recreational value, social groups including athletic teams and youth bands, or traditional pastimes such as parades, give children a chance to be active and respected members of their community. Similarly, community service, volunteering, and religious youth groups help children to learn the value of serving others and offer a chance to practice compassion and empathy at an early age. Engaged in their communities, children can respond to many of today's challenges. Printed in newspapers, distributed throughout communities, and saved by generations, photographs can further foster a sense of community pride and civic engagement. The following images demonstrate the many ways children define community.

*Parade Thrills*,
May 17, 1979
Milton Williams
—
Drum major Victor Fuller leads the H. D. Woodson High School marching band down Pennsylvania Avenue during the 25th anniversary of *Brown v. Board of Education* victory march to the U.S. Capitol.

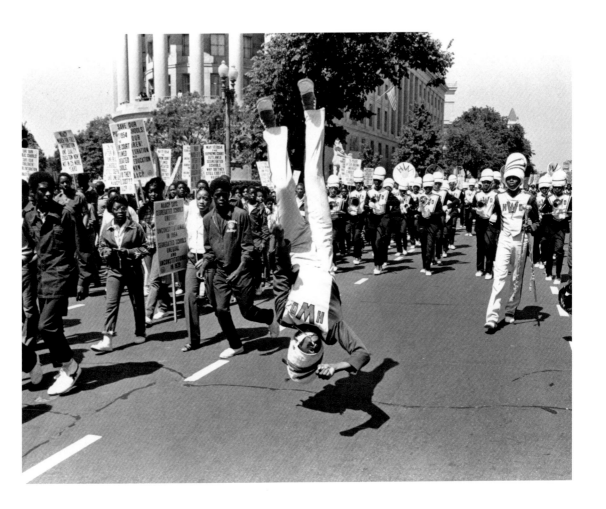

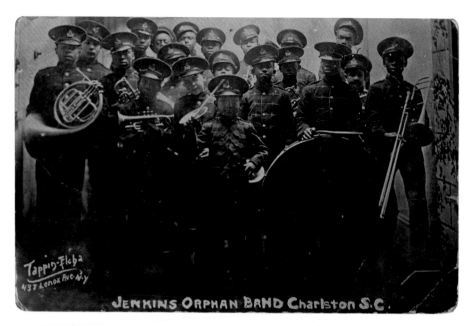

**Jenkins Orphanage Band, Charleston, South Carolina**, 1914
Edward Elcha and Percy Tappin

—

In 1891, the Reverend Daniel J. Jenkins opened the Jenkins Orphanage for African American boys in Charleston, South Carolina. Unable to provide for the growing number of boys under his care, Rev. Jenkins asked members of the Charleston community to donate used musical instruments, with the intention of raising money for the orphanage by forming a traveling band. Wearing discarded military uniforms from The Citadel, the band performed a mix of military marches, folk tunes, and ragtime throughout the United States and in Europe. The boys played in the inaugural parades of Presidents Theodore Roosevelt and William Howard Taft. They also appeared at the 1904 St. Louis World's Fair and the 1914 Anglo-American Exposition, where they performed for members of the British Royal Family.

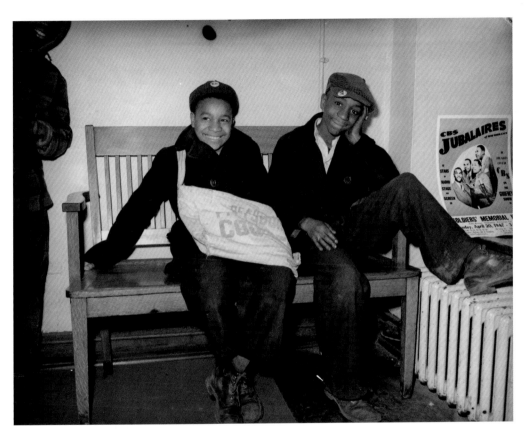

*Pittsburgh Courier*
**paper boys sitting on
a bench**, 1947
Charles "Teenie" Harris

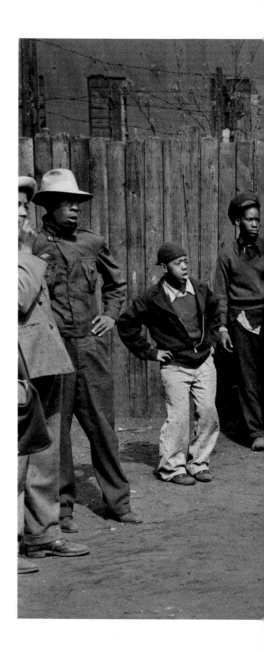

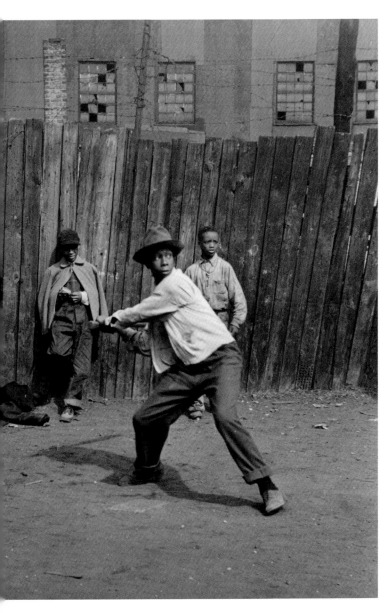

**Untitled**, 1946–48
**Sandlot baseball**
From the series **The Way
of Life of the Northern
Negro**
Wayne F. Miller
—

From 1946 to 1948,
photographer Wayne F.
Miller immersed himself
into the lives and culture of
the citizens of Bronzeville,
a community of African
American migrants on
Chicago's South Side. Miller's
subjects were everyday
people struggling to make
a life for themselves in
this strangely new urban
setting after making the
journey north as part of
the Great Migration. Miller
wrote that his "search was
for the everyday realities of
life – *their* view of the world,
*their* feelings, *their* attitudes,
*their* differences." Miller's
photographs, like this image
of a group of young men
and boys playing a game of
stickball, show glimpses of
both the hardship and the
optimism that defined this
community.

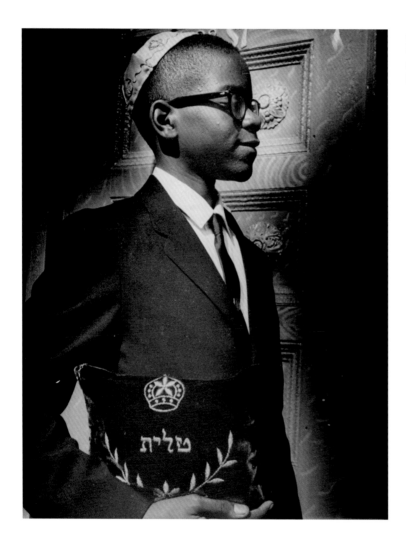

**A boy in a yarmulke,
Harlem, New York,**
ca. 1960
Lloyd W. Yearwood

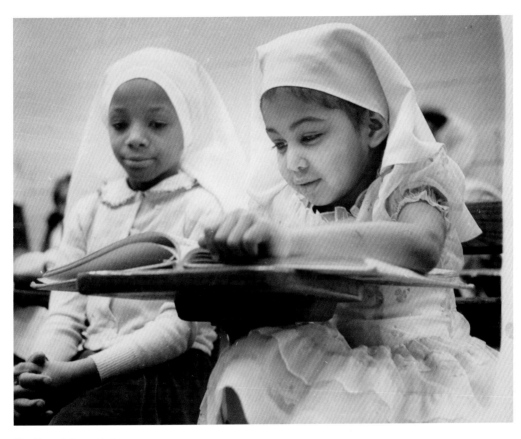

**Muslim girls seated
in a classroom
reading**, ca. 1960
Lloyd W. Yearwood

**A young couple at prom**, ca. 1960
Rev. Henry Clay Anderson
—
Richard Williams with his prom date, Dorothy Black, at Coleman High School prom in Greenville, Mississippi.

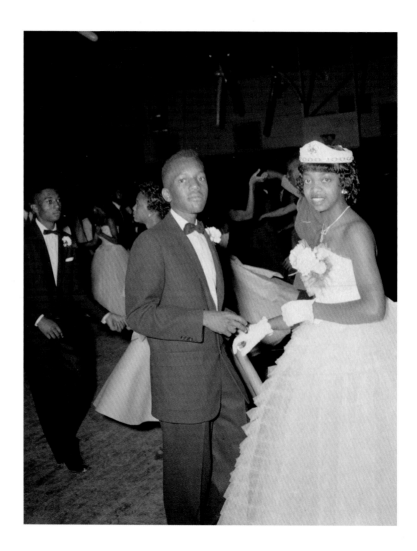

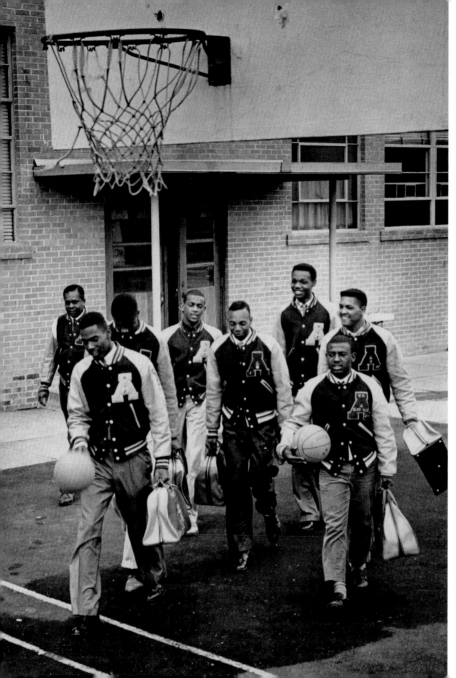

**Basketball team from St. Augustine High School, New Orleans, Louisiana**, after 1951
Frank J. Methe

**_Valerie Wilson at the Intercommunal Youth Institute, Oakland, 1971_**; printed 2014
Stephen Shames
—

In January 1971, the Black Panther Party officially launched its Intercommunal Youth Institute in the San Francisco Bay Area. A culmination of earlier education programs, the institute was the first fully accredited Panther school. It initially served children of Panther Party members, but quickly expanded to serve the larger community. By 1973, the Black Panther Party established a permanent home for the institute in East Oakland, California, renaming it the Oakland Community School. The school's vision centered on its motto "Learning how to think, not what to think."

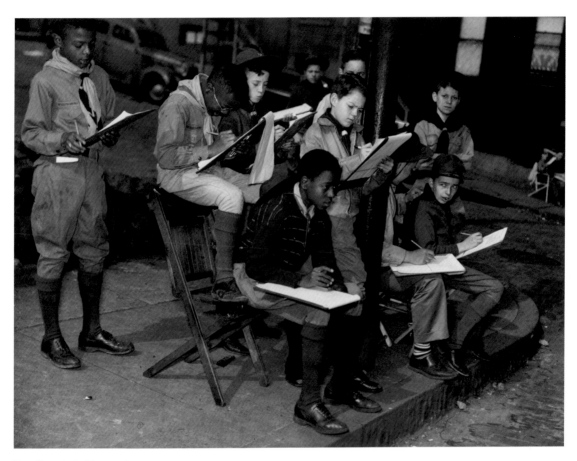

**Boy Scouts taking notes
on a Pittsburgh street
corner**, ca. 1945
Charles "Teenie" Harris

# PLAY

Play is a necessary part of every child's life and supports social, emotional, intellectual, and physical development. It is through play that children first understand each other and make sense of the world around them. As children gain a sense of identity and learn new concepts through play, they develop self-confidence and self-esteem. Though adults most often make the decisions in children's lives, play allows children rare moments of mastery over their world. Children can assume different roles: explorer, leader, nurturer, adventurer, supporter, and discoverer. More and more research suggests that healthy playtime leads to a healthy adulthood.

The images in this section capture experiences of play, offering insight into children's culture while also documenting developmental milestones. For example, Joe Schwartz's photograph *Kid-Folks Touching* captures two friends engaged in playground acrobatics, holding hands while hanging upside down and back to back, a precarious position that required the children to communicate and negotiate with each other. In this moment, each child acts as an explorer and supporter—roles important to appreciate and practice in life. From childhood to adulthood, play promotes healthy development and sustains wellbeing. The following images celebrate children at play.

***Kid-Folks Touching***,
1940s
Joe Schwartz

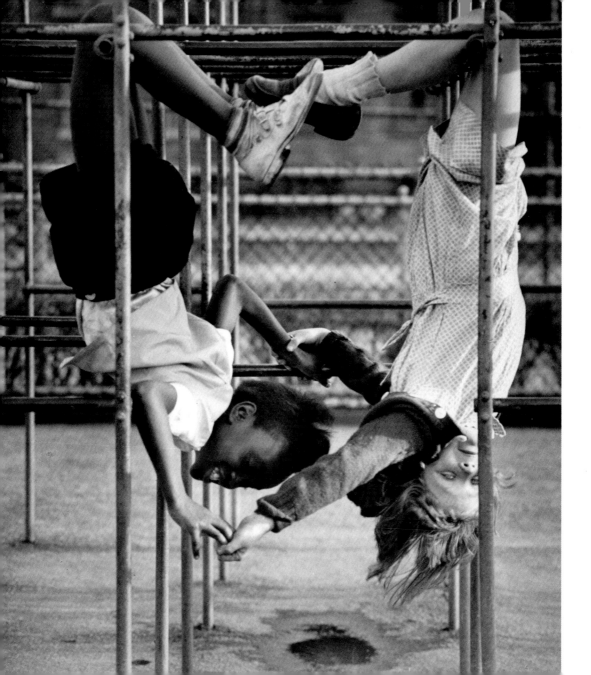

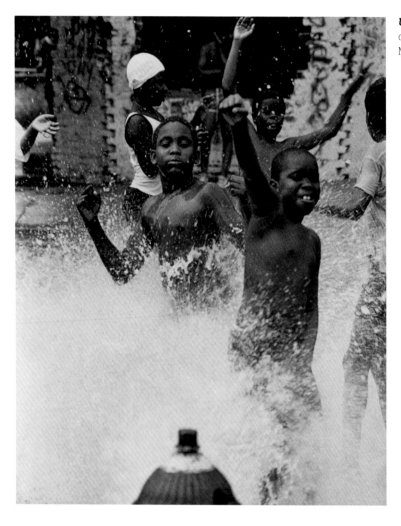

**Untitled**, late 20th century
Milton Williams

**Untitled**, 1946–48
**Young boxer at Edie Nichols Gymnasium**
From the series **The Way of Life of the Northern Negro**
Wayne F. Miller

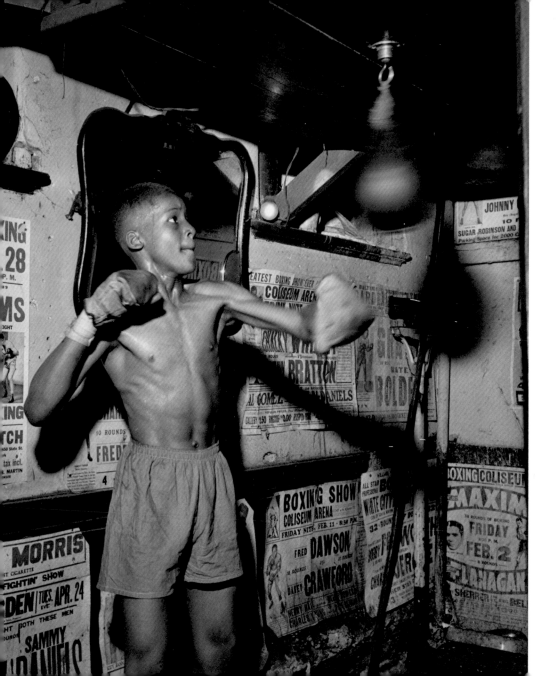

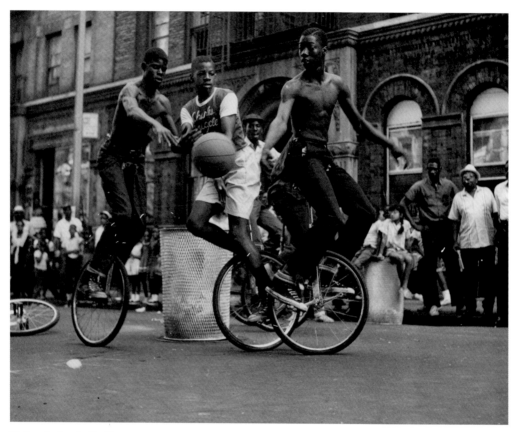

**Unicycle basketball**,
ca. 1960s
Lloyd W. Yearwood

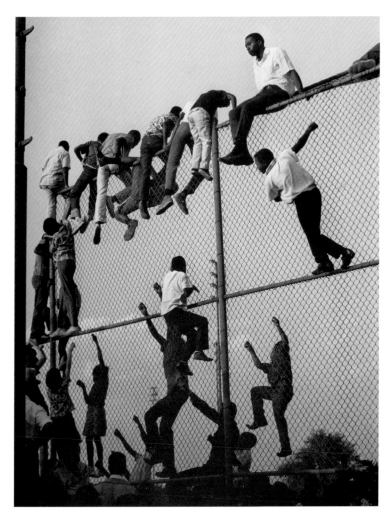

**First Watts Festival,**
1965
Joe Schwartz

### *Upstate New York · USA*, 1963
### Leonard Freed
—

A summer camp in Chappaqua, New York, hosted boys from the inner city, regardless of their racial or ethnic background. The boys enjoyed many hours of outdoor play, sports, and nature walks at the camp, which aimed to provide a respite from the dense urban landscape. Photographers Leonard and Brigitte Freed visited the camp for a few days to photograph the children and counselors, and remarked on the atmosphere of camaraderie and goodwill.

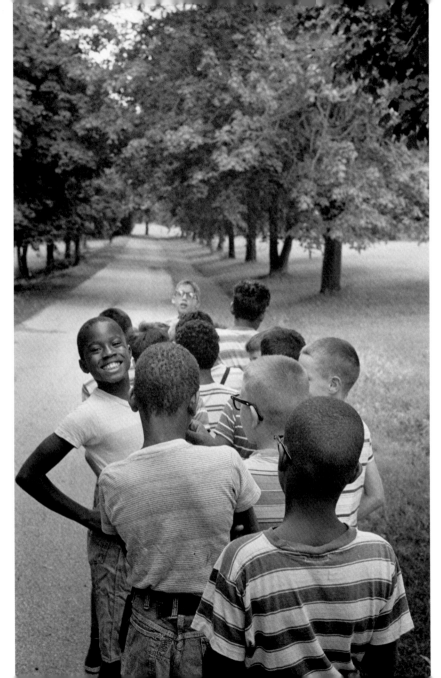

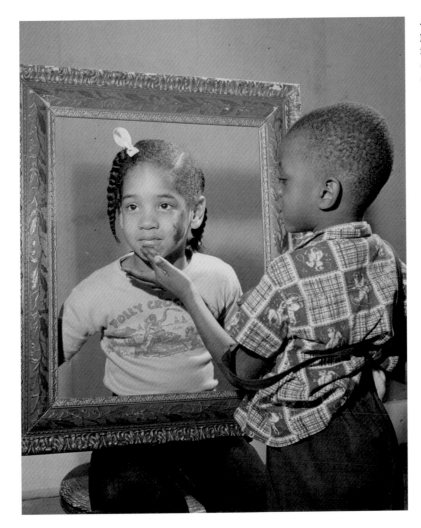

**A young girl and boy posing with a picture frame**, mid-20th century
Gaston L. DeVigne II

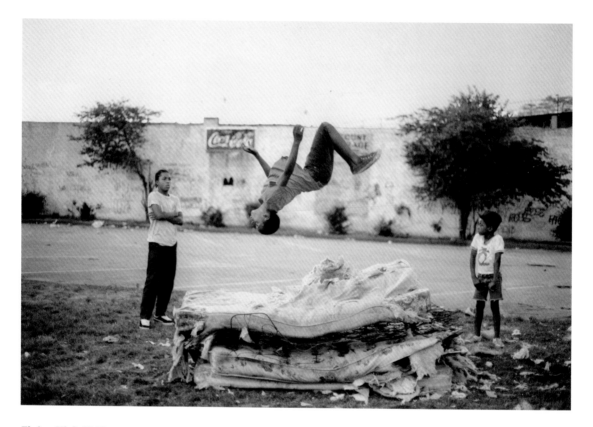

***Flying High***, 1981;
printed 2010
From the series
**Back in the Days**
Jamel Shabazz

**Flying High**

I fell in love with photography over thirty years ago and I made it a point to carry my camera everywhere I went. For me, it was the ability to freeze any motion that marveled me the most. The images I created were all a part of my visual diary, documenting my journey and the people I met.

In capturing *Flying High*, I was just off a training session with my father, who was a professional photographer. He recognized my enthusiasm for photography and pushed me to understand all of the fundamentals. My father explained the importance of knowing and mastering the settings on my Canon AE1 SLR camera. Upon completion of each lesson, he would put me on assignment to see if I was paying attention.

While exploring my community on a hot summer day, I came upon four teenage boys taking turns flipping on an old, beat-up mattress, each one demonstrating incredible skill. I watched them in amazement, reminiscing about when I was their age and how I would be doing pretty much the same thing with my friends. Without hesitation, I checked the settings on my camera, remembering everything my father told me about light and speed. I positioned myself with the sunlight behind me, lifted my camera to my face, and took a deep breath, slowly pressing the shutter-release button, as I captured this gifted child in a perfect backspin. I knew in my heart I had captured the moment, but it wasn't until I saw the image in print that I knew I had recorded a very important moment in history. My father never cared much for my work, but when he saw *THAT* image he congratulated me! Sadly, I would never see those talented acrobats again, but often wondered what happened to them. *Flying High* would go on to be one of my most iconic images.

Jamel Shabazz, 2015

# PORTRAITS

When commercial photography studios emerged in the mid-nineteenth century, photography quickly supplanted painting and drawing as the primary means to render a portrait. For the first time, it was possible for people from all social classes, not just the wealthy and elite, to own and share their likenesses with others. With today's social media–driven culture of selfies and profile pictures, portraits remain one of the most fundamental ways to communicate identity and track milestones. Portraits of children help to show development and growth, while reinforcing their stories and concepts of identity.

In addition to being a tool for defining self, portraits are also a means of understanding and relating to others. For young children especially, portraits have an impact on how they view others. Exposure to different types of people can reduce the development of prejudice and stereotyping later in life. Further, seeing photographs of people experiencing a wide range of emotions builds empathy and helps children understand the complexity of the world in which they live.

Many of the images in this section are posed portraits made in a studio setting, following conventions of portraiture wherein the subject's personalities are revealed by their pose, expression, or clothing. Others are more candid, capturing moments that—like childhood—are fleeting.

*Untitled*, 1946–48
From the series **The Way of Life of the Northern Negro**
Wayne F. Miller

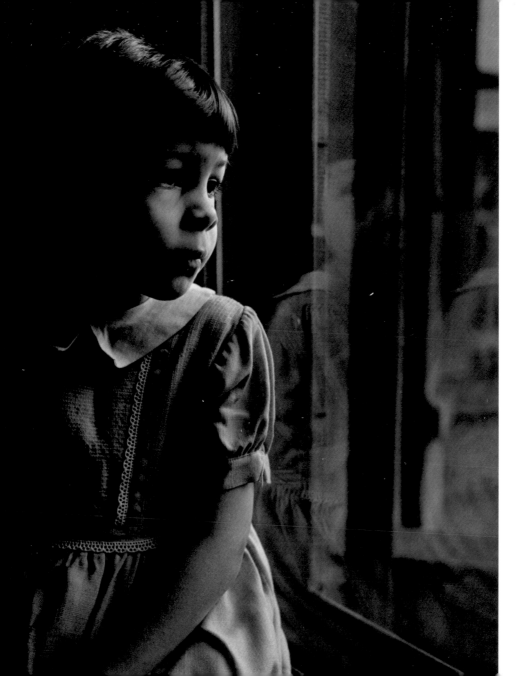

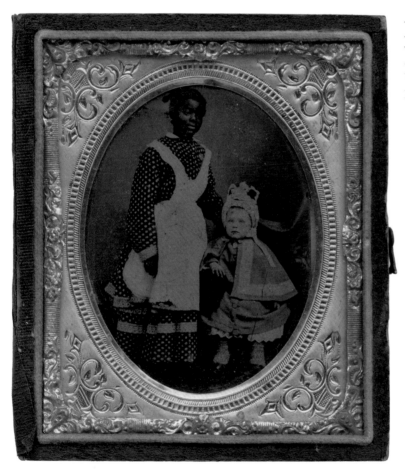

**A young African American woman with a white child**, ca. 1860
Unidentified photographer

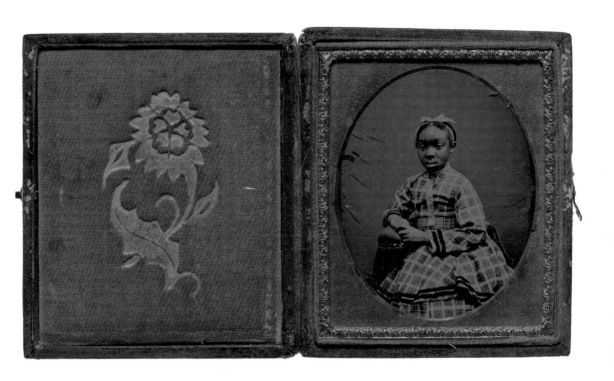

**Girl in a plaid dress**,
1870s
Unidentified
photographer

**P. H. Polk, Jr.**, 1929
P. H. Polk

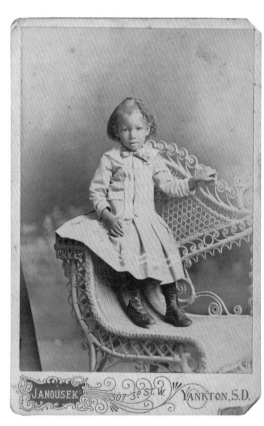

**A toddler standing on
a wicker chair**, late
19th century
Louis Janousek

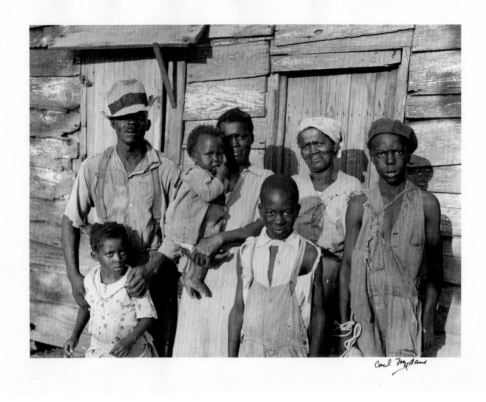

Carl Mydans

**Rehabilitation Client and His Family on Lady's Island off Beaufort, SC,**
1936; printed 1993
Carl Mydans

In 1935, the United States Resettlement Administration (RA) launched one of the most influential photography projects of the modern era. With Roy Stryker as its director, the RA, which became the Farm Security Administration (FSA) in 1937, produced an extensive visual record of America during the Great Depression. A product of Franklin Roosevelt's New Deal, the RA and FSA documented America's cultural landscapes while setting enduring standards for twentieth century photography. Images like this portrait of Lewis Hunter and his family in front of their wooden cabin were used as evidence to demonstrate the need for New Deal loans and assistance programs to help poor farmers.

**A boy holding a football**, mid-20th century
Rev. Henry Clay Anderson

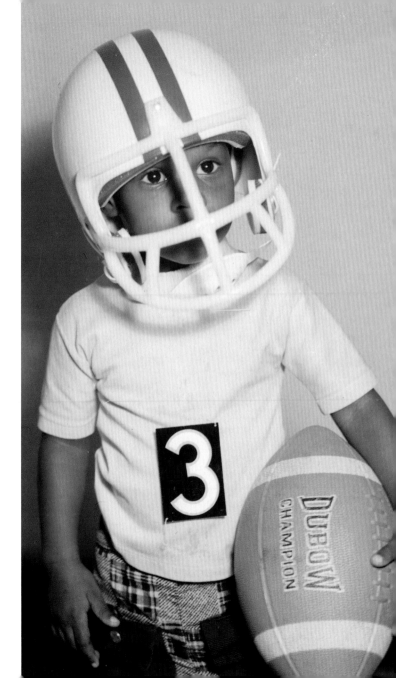

**A young girl holding
a telephone handset**,
after 1955
Rev. Henry Clay
Anderson

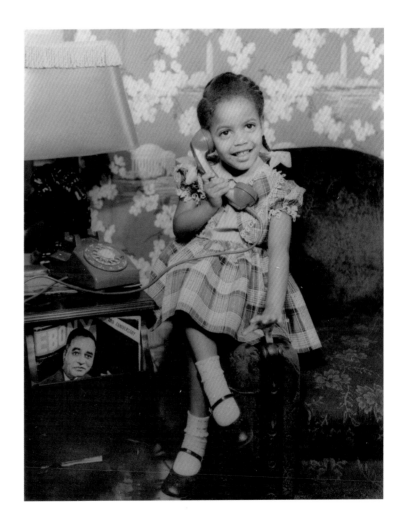

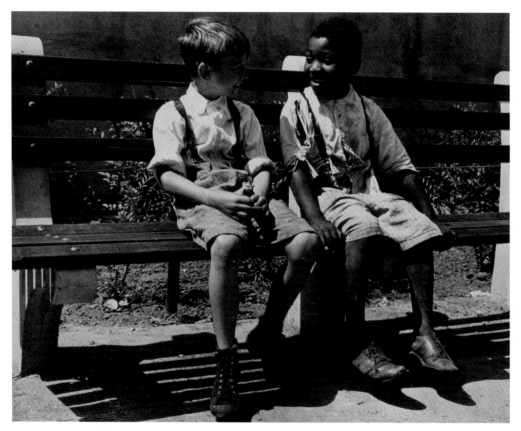

***Two's a Team***, 1940s
Joe Schwartz

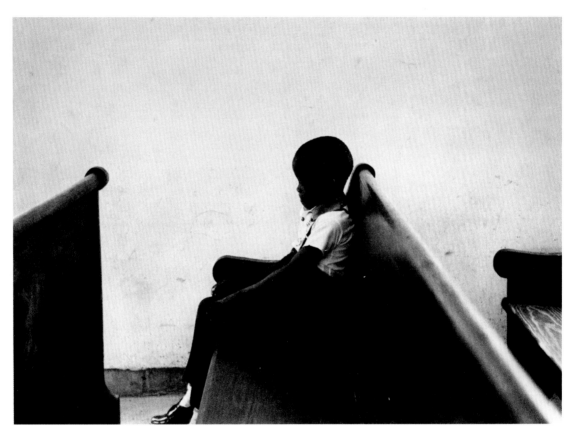

***Pews***, 1958; printed 2009
George Krause

*Unititled (Ballerina at Brooklyn Music School)*, 1992; printed 2009
LeRoy W. Henderson

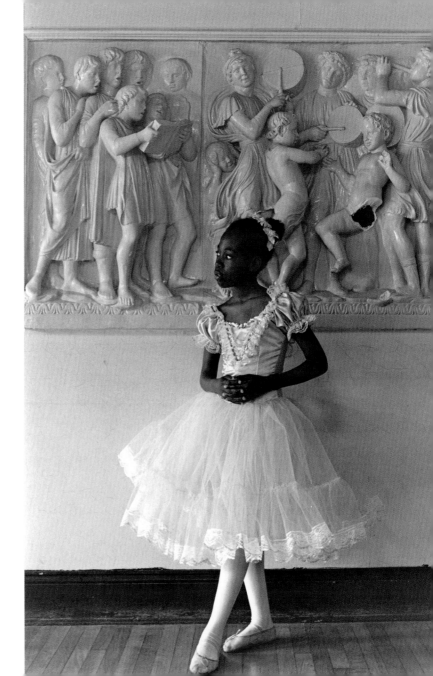

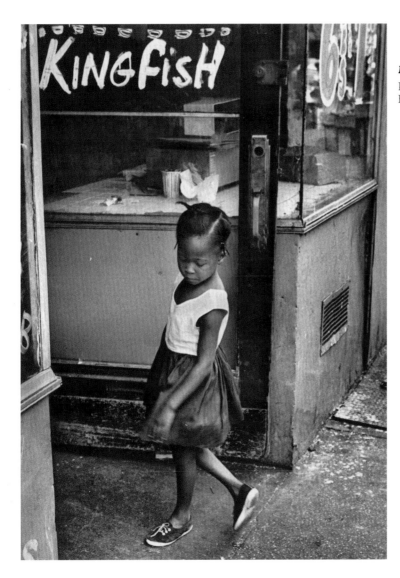

**Kingfish**, 1965;
printed 2015
Builder Levy

***Twins at WDIA,
Memphis, TN***, 1948
Ernest C. Withers

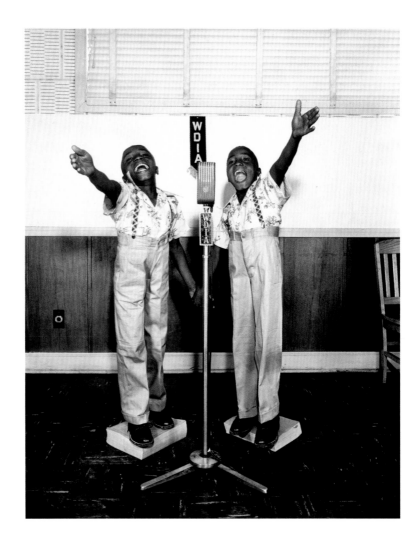

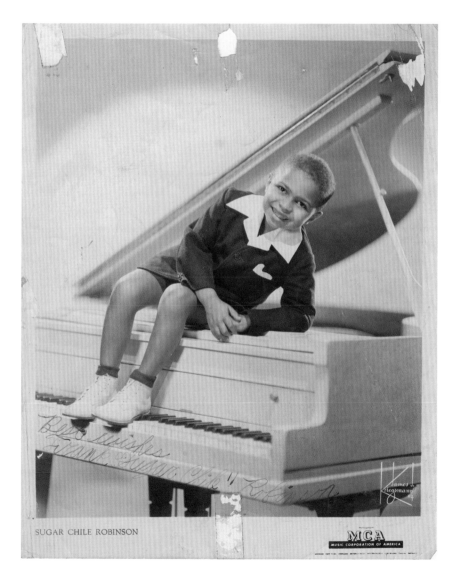

SUGAR CHILE ROBINSON

MCA
MUSIC CORPORATION OF AMERICA

**Frank "Sugar Chile" Robinson**, 1940s
James J. Kriegsmann
—

Self-taught child prodigy Frank "Sugar Chile" Robinson was born in Detroit, Michigan, on December 28, 1938. By age two, he was playing the piano. At age seven, he debuted in the film *No Leave, No Love* (1946), where he performed one of his most popular songs, "Caldonia." Known for his soulful singing of the blues and his signature style that included banging on the piano with his elbows and fist, Robinson recorded several albums for Capitol Records, played with numerous jazz musicians including Lionel Hampton and Count Basie, and toured nationally and internationally—famously performing for President Harry S. Truman in 1946 at the White House.

# ACTIVISM

If you have ever been around a child, you have most likely heard an outraged cry of "That's not fair!" Children tend to think about right and wrong in strict terms of absolutes, rules, and their own perspective. When empowered and given the opportunity, children can have the strongest voices for change. During the early stages of life, children develop moral beliefs. How they think about right and wrong are not only as important as letters and numbers, but equally as significant. Such moral issues involve concepts such as justice, fairness, and human rights.

Morality and prejudice often coexist. Studies have shown that prejudicial thinking develops within the first eight years of a person's life. Navigating the social world poses many challenges for young people, as they receive mixed messages from adults and through the media. People are constantly faced with difficult and complex decisions about inclusion and exclusion of others. With a more complete understanding of this development in childhood, adults will be able to help the children in their lives to avoid damaging prejudices, ultimately leading to a more just and fair society and shared community.

Whether it was being the first students to desegregate a school, or involvement in the March on Washington, children were not only present during the Civil Rights Movement but were active leaders. Thus, children are subjects of some of the most searing photographs of the time, which in turn had a profound impact on social reform. Images of youth being attacked while peacefully protesting made global headlines, prompting political leaders to respond. This resulted in the integration of public facilities and eventually contributed to the passing of the Civil Rights Act of 1964. There are many ways to be an activist. Indeed, one of the greatest opportunities for change begins with young children learning to see the humanity in other people. As the following images make clear, everyone can make a difference—no matter how young.

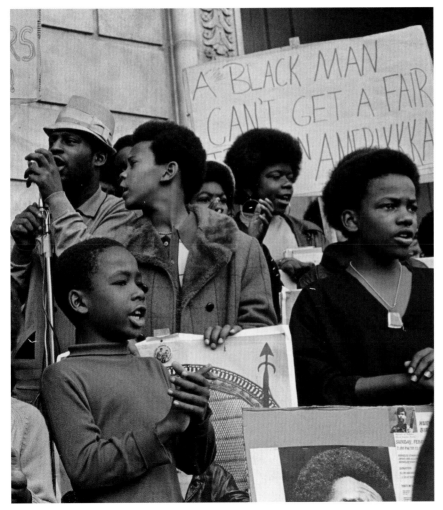

**Free Huey/Free Bobby Rally, San Francisco, California, 1970**; printed 2014 (detail) Stephen Shames

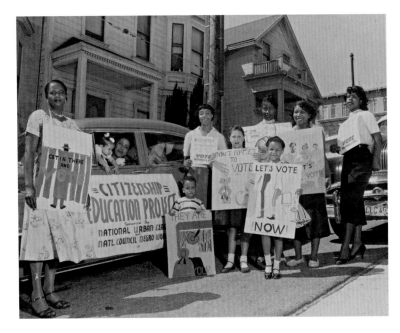

**Women and children
at voter registration
motorcade,**
September 8, 1956
Cox Studio

*"We have a powerful potential in our youth,
and we must have the courage to change old
ideas and practices so that we may direct their
power toward good ends."*

Mary McLeod Bethune

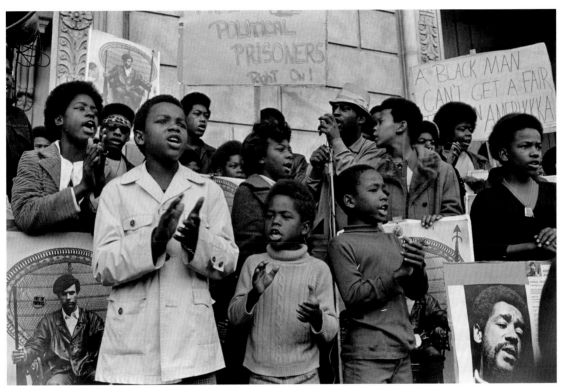

*Free Huey/Free Bobby Rally, San Francisco, California, 1970*; printed 2014
Stephen Shames

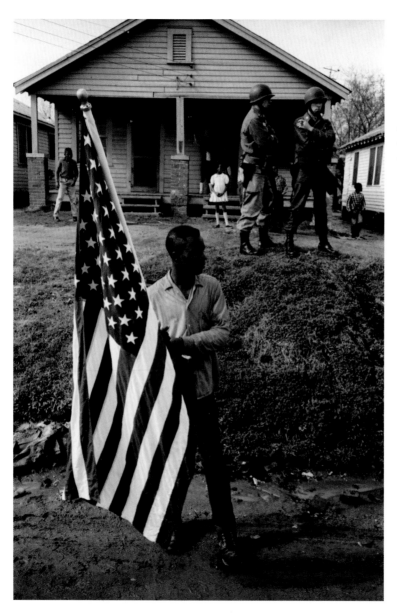

*Young Marcher,*
*Selma to Montgomery*
*March*, 1965
James H. Karales

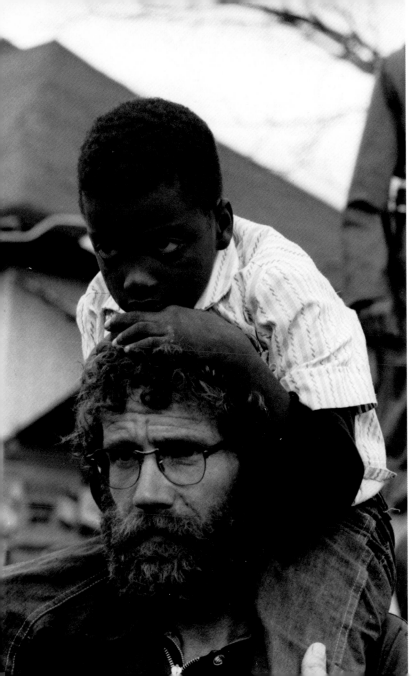

*Faces in the Crowd,*
*Selma to Montgomery*
*March*, 1965
James H. Karales

***Untitled***, 1968
Robert Houston

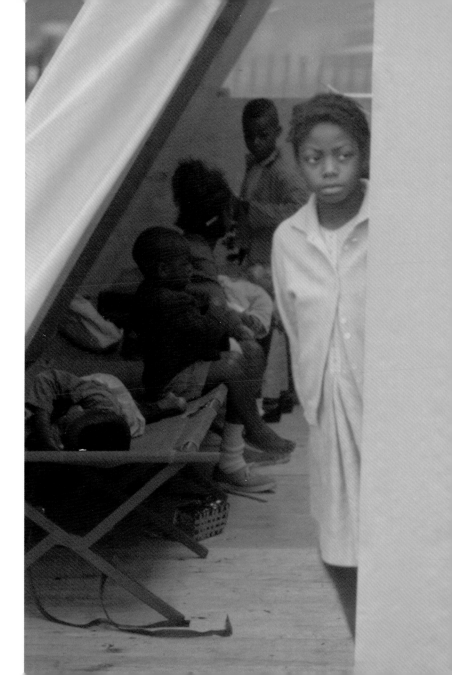

## Children of Resurrection City –
## A Teacher's Perspective

In May 1968, people began flooding into Washington, D.C., for the Poor People's March. People came from everywhere—some actually came in mule-drawn wagons to the campsite, Resurrection City. People looked forward with great anticipation to seeing how this movement would impact the day-to-day life of the nation's capital. Our major concern was how to provide a quality experience for the young children, while their parents were marching, protesting, and fighting for equal rights and economic justice during the day. As a committed early childhood educator, I was very interested in being a part of this effort.

The National Capital Area Child Daycare Association (NCACDA), an organization with multiple licensed centers throughout the city, was brought in to organize a program for the preschool children. I was a teacher at one of the NCACDA centers—Sargent Memorial Daycare Center located in northeast Washington.

After working the early shift at Sargent Memorial Daycare Center, a fellow teacher and I would catch the bus to Resurrection City on the National Mall to work from 3 p.m. until 5 p.m. There were three major class-rooms: one for infants and children who did not walk and two for preschoolers. There were a few full-time volunteers and a number of part-time volunteers who worked in shifts throughout the day.

We provided age-appropriate activities in art, music, language, shapes, colors, and numbers. It was also extremely important to give the children time to express themselves—their feelings and impressions of what was going on. Our goal was to help these children feel safe and cared for during their time in Resurrection City. As preschool teachers, we were well trained to provide them with a nurturing environment.

I remember that we were inspired to be involved because we understood that the Poor People's Campaign and Resurrection City were integral to bringing national attention to the plight of the poor. It was important to focus on the crucial need for quality care and education for disadvantaged children. Even though we were exhausted working full-time jobs and volunteering every day, the plight of these children was too critical to ignore. It was a privilege to be involved. It was gratifying to help the children in some small way and to be a part of this historical moment.

Margaret A. Dodson-Turner, 2015

**The March on
Washington for Jobs
and Freedom Took
Place in Washington,
D.C., on August 28,
1963**; scanned 2010
James H. Wallace

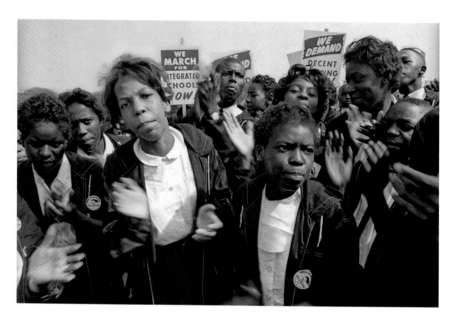

"I can still hear all of these children singing these songs,
and 'Keep on a'walking, keep on a'talking, marching
on to Freedom Land.' And, amazingly, it gave you the
strength to keep going, just to keep going."

Dr. Freeman Hrabowski III, 2011 (12 years old during the Birmingham Children's Crusade)

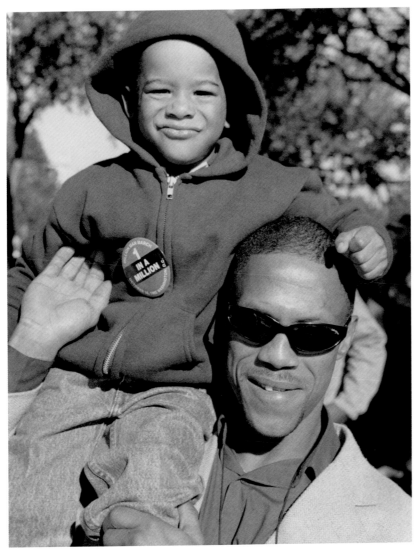

*Father & Son*,
October 16, 1995
From the series
**One Million Strong**
Roderick Terry

—

On October 16, 1995,
hundreds of thousands
of African American men
gathered on the National
Mall in Washington, D.C.,
for the Million Man March,
a rally promoting personal
responsibility and racial
solidarity among African
American men. Led by
Louis Farrakhan of the
Nation of Islam, a range of
civil rights organizations
came together to plan
and participate in the
event. Speakers called
on black men to stand up
and take responsibility for
themselves, their families,
and their communities.

## Honest Resilience

As children we learn early to hold our blackness. The joy of it is matched by a haunting weight that grows as we grow. It floats above the strike of jump ropes on concrete. It soars above hopscotch roadmaps, drawn with chalk that might one day betray our silhouettes. We grasp it with grace. Early we learn to hold our blackness in the balance. Still, black children have the wisest joy, a most resilient instinct in a society that denies us childhood. We grow up fast, not because our bones are quicker than others, but because racism has a stake in denying us our innocence, and even our lives. At seven years old, Aiyana Jones reminded us of how foundational this truth is in the United States. At seven years old, a police raid reminded us that law enforcement does not hold sacred black children as we do.[3]

Our future relies on our ability to protect black children in all of their brilliance. It depends upon whether or not we can continue to love them so deeply that we imagine a future without white supremacy and without state violence. It depends upon how honestly we see ourselves floating in the balance they strike between the joy they deserve and the joy we as black people are denied. Our future is more complicated than Double Dutch, but our leap into that future demands that same endurance and fearless imagination.

Patrisse Cullors and Mark-Anthony Johnson, 2015

**A young girl at a Baltimore City Hall rally**, May 3, 2015 Devin Allen

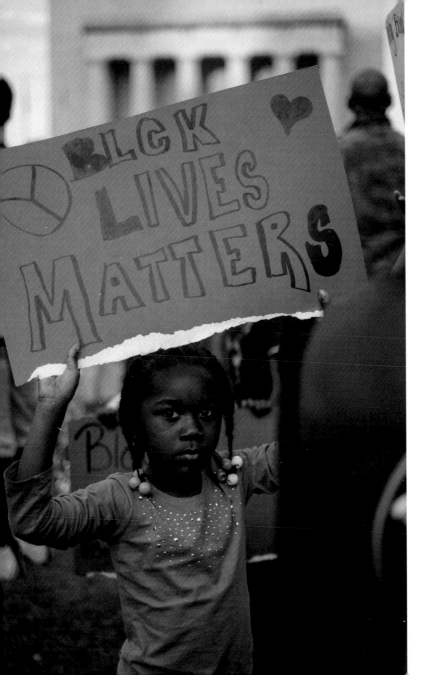

**Seven of the Little Rock
Nine meeting at the
home of Daisy Bates**,
March 1958
Gertrude Samuels
—

The American Civil
Rights Movement's
effort to desegregate
southern schools was
a key part of the highly
contested struggle
to integrate America.
Beginning in 1957, the
National Association
for the Advancement of
Colored People (NAACP)
met with massive
resistance in their efforts
to implement the United
States Supreme Court's
1954 *Brown v. Board of
Education* decision to
end racial segregation
in America. Rather
than comply with the
decision, public officials

like Arkansas Governor
Orval Faubus employed
various tactics of
opposition. Governor
Faubus mobilized the
Arkansas National Guard
and initially prevented
nine black students,
identified by the media
as the Little Rock Nine,
from attending Central
High School in Little Rock.
While federal troops
were present to enforce
the law, the students
were not shielded from
verbal and physical
attacks. Pictured here
are Melba Patillo, Carlotta
Walls, Jefferson Thomas,
Elizabeth Eckford, Thelma

Mothershed, Terrence
Roberts, and Gloria Ray
studying at the home
of Daisy Bates, a local
NAACP leader.

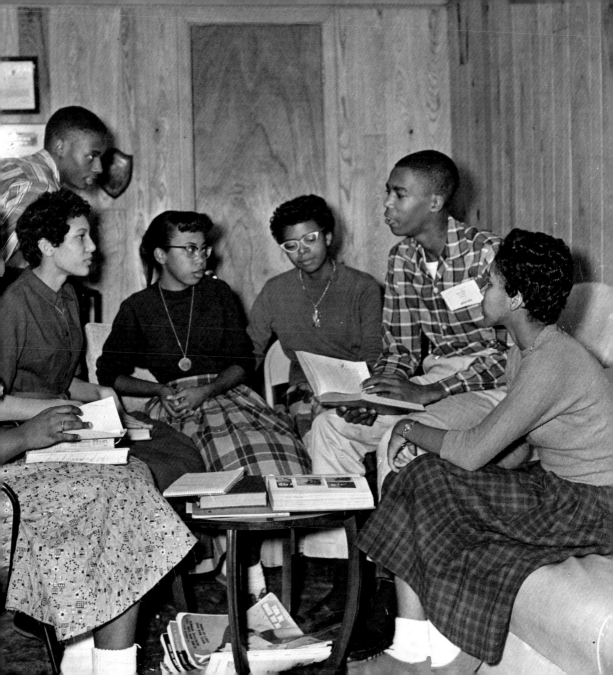

**_Brown Sisters_**
**_Walk to School_**,
1953; printed 2011
Hikaru Carl Iwasaki

Shown here are sisters
Linda (b. 1942) and
Terry Brown (b. 1947),
walking through a railway
switchyard to attend
Monroe Elementary
School, an all-black
school in Topeka, Kansas.
Segregation laws
prevented them from
attending New Sumner,
a nearby white school.
Linda Brown became
a plaintiff in _Brown v._
_Board of Education_, the
lawsuit that challenged
the constitutionality of
American segregation.

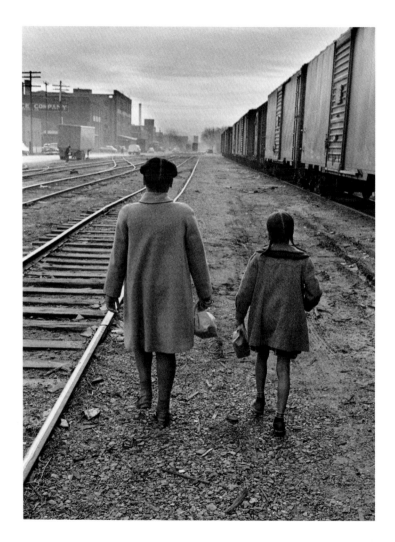

# Index

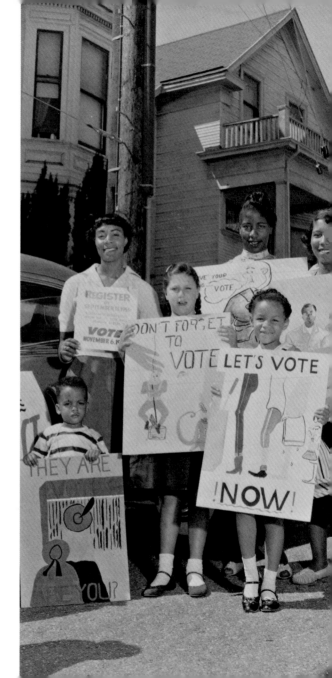

Strohmeyer & Wyman
*Cotton is King – Plantation
Scene, Georgia*, 1895
stereograph
H x W (Image and Mount):
3½ × 7¹⁄₁₆ (8.9 x 17.9 cm)
Gift of Oprah Winfrey
2014.312.171
Page 26

Roderick Terry
*Father & Son*, October 16, 1995
From the series **One Million
Strong**
gelatin silver print
H × W (Image and Sheet):
11 × 14 in. (27.9 × 35.6 cm)
Gift of Roderick Terry
2013.99.42
© Roderick Terry
Page 79

Unidentified photographer
**Family in front of Georgia home**,
1930s
ink on paper
H x W (Image and Sheet):
3½ × 5½ in. (8.9 × 14 cm)
2010.36.8.8
Page 11

Unidentified photographer
**Girl in a plaid dress**, 1870s
tintype
H × W × D (Case open):
3¾ × 6½ × ¼ in. (9.5 × 16.5 × 0.6 cm)
H × W × D (Case closed):
3¾ × 3½ × ½ in. (9.5 × 8.9 × 1.3 cm)
Gift of Oprah Winfrey
2014.312.115
Page 59

Unidentified photographer
**James Baldwin and
Paula Baldwin**, 1953
gelatin silver print
H × W (Image and Sheet):
5 × 3½ in. (12.7 × 8.9 cm)
Gift of The Baldwin Family
2011.99.39
Page 33

Unidentified photographer
**Senator Henry Hall Falkener
and family**, ca. 1905
gelatin silver print
H × W (Image and Mat):
8⅞ × 5⅞ in. (22.5 × 14.9 cm)
Gift of Margaret Falkener
DeLorme, Waldo C. Falkener,
Cameron S. Falkener and Gilbert
E. DeLorme
2014.94.16
Page 23

Unidentified photographer
**Valdora Turner as a young girl**,
ca. 1922
gelatin silver print
H × W (Image and Sheet):
6½ × 4½ in. (16.5 × 11.4 cm)
Gift of Jacqueline E. McCoy and
Charles Frazer III
2011.77.1
Page 6

Unidentified photographer
**A woman and four children**, 1870s
tintype
H × W: 3⅝ × 2½ in. (9.2 × 6.4 cm)
Gift of Oprah Winfrey
2014.312.128
Page 22

Unidentified photographer
**A young African American
woman with a white child**,
ca. 1860
tintype
H × W: 3¼ × 2¾ in. (8.3 × 7 cm)
2008.9.6
Page 58

James H. Wallace
*The March on Washington for
Jobs and Freedom Took Place in
Washington, D.C., on August 28,
1963*; scanned 2010
digitized acetate negative
Gift of James H Wallace Jr.
2011.11.31
© Jim Wallace
Page 78

Milton Williams
*Parade Thrills*, May 17, 1979
gelatin silver print
H × W (Image and Sheet):
11 × 14 in. (27.9 × 35.6 cm)
Gift of Milton Williams Archives
2011.15.257
© Milton Williams
Page 35

Milton Williams
*Untitled*, late 20th century
gelatin silver print
H × W (Image and Sheet):
9¹⁵⁄₁₆ × 7⅞ in. (25.2 × 20 cm)
Gift of Milton Williams Archives
2011.15.48
© Milton Williams
Page 48

Ernest C. Withers
*Twins at WDIA, Memphis, TN*,
1948
gelatin silver print
H × W (Image and Sheet):
20 × 16 in. (50.8 × 40.6 cm)
2009.16.22
© Ernest C. Withers Trust
Page 68

Lloyd W. Yearwood
**A boy in a yarmulke, Harlem,
New York**, ca. 1960
ink on paper
H × W (Image and Sheet):
8⅛ × 10 in. (20.6 × 25.4 cm)
2014.150.9.7
© Estate of Lloyd W. Yearwood
Page 40

Lloyd W. Yearwood
**Muslim girls seated in a
classroom reading**, ca. 1960
gelatin silver print
H × W (Image and Sheet):
11 × 14 in. (27.9 × 35.6 cm)
2014.150.9.5
© Estate of Lloyd W. Yearwood
Page 41

Lloyd W. Yearwood
**Unicycle basketball**, ca. 1960s
gelatin silver print
H × W (Image and Sheet):
11 × 14 in. (27.9 × 35.6 cm)
2014.150.3.26
© Estate of Lloyd W. Yearwood
Page 50

### Endnotes

1  W. E. B. Du Bois, "Opinion of
W. E. B. Du Bois," *The Crisis*,
vol. 24, no. 6, (October 1922),
247.

2. "A 2007 article in the *Journal of
Marriage and Family* found that
75 percent of white families
with kindergartners never, or
almost never, talk about race.
For black parents the number
is reversed, with 75 percent
addressing race with their
children." –"Kids' Test Answers
on Race Brings Mother to
Tears." CNN. May 25, 2010.
Accessed September 14, 2015.

3. On May 16, 2010, seven-
year-old Aiyana Jones was
shot and killed during a raid
conducted by the Detroit
Police Department. After two
mistrials, the officer charged in
connection with Jones's death
was cleared of all charges.